VERSE FOR HEALING

MIDNIGHT EDITION

"HE HAS BLINDED THEIR EYES AND HARDENED THEIR HEART, LEST THEY SEE WITH THEIR EYES, AND UNDERSTAND WITH THEIR HEART, AND TURN, AND I WOULD HEAL THEM.

John 12:40

A BIBLE VERSE COLORING BOOK

Date: _____

TO: _____

From: _____

Copyright: Published in the United States by V Art

Published March 2017

All rights reserved.

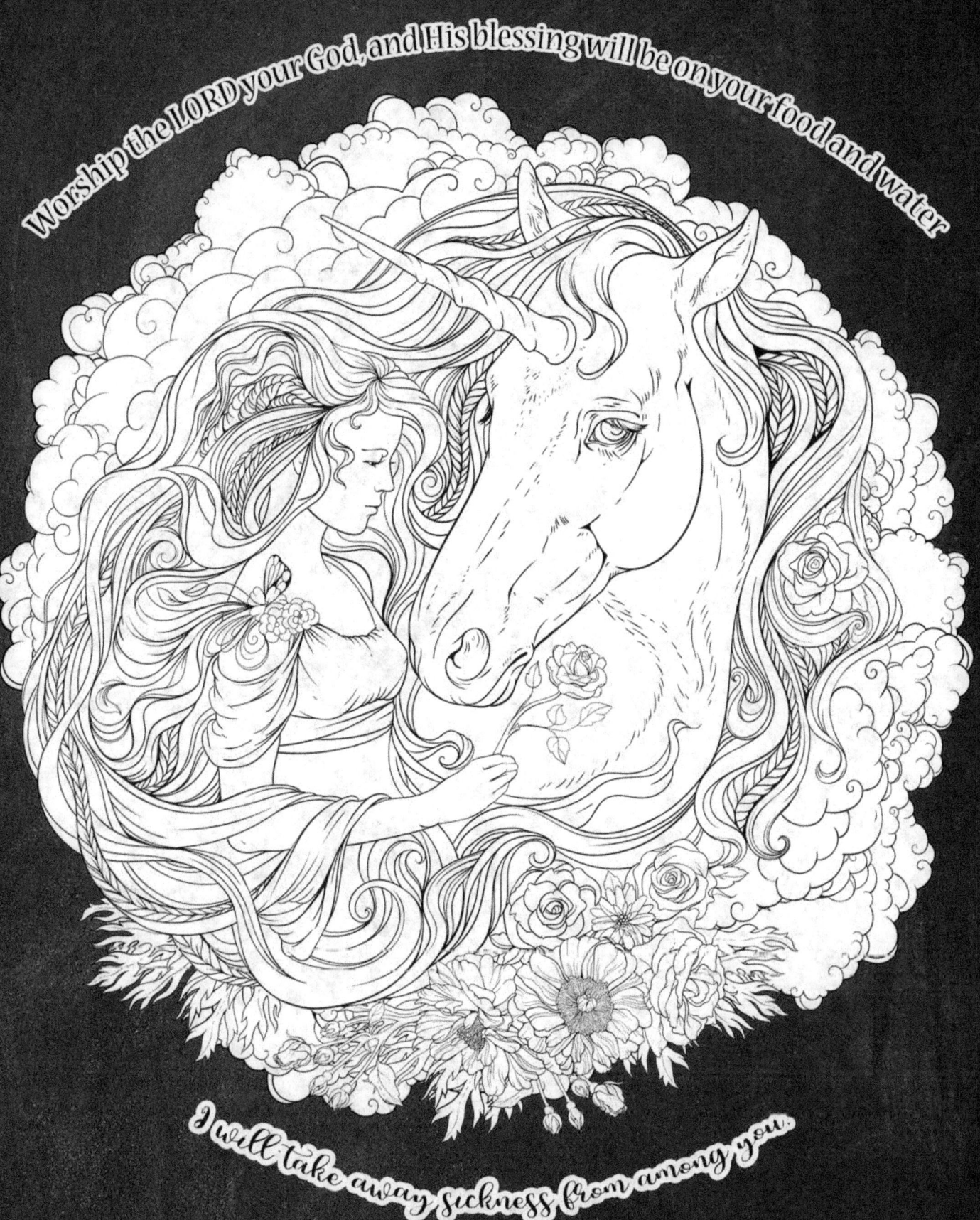

Worship the LORD your God, and His blessing will be on your food and water. I will take away sickness from among you.

EXODUS 23:25

PSALM 34:20

"See now that I, even I, am he,

and there is no god beside me;

I kill and I make alive;

I wound and I heal;

and there is none that

can deliver out of my hand.

DEUTERONOMY 32:39

Have compassion on me, LORD

for I am weak. Heal me, LORD,

for my bones are in agony.

Psalm 6:2

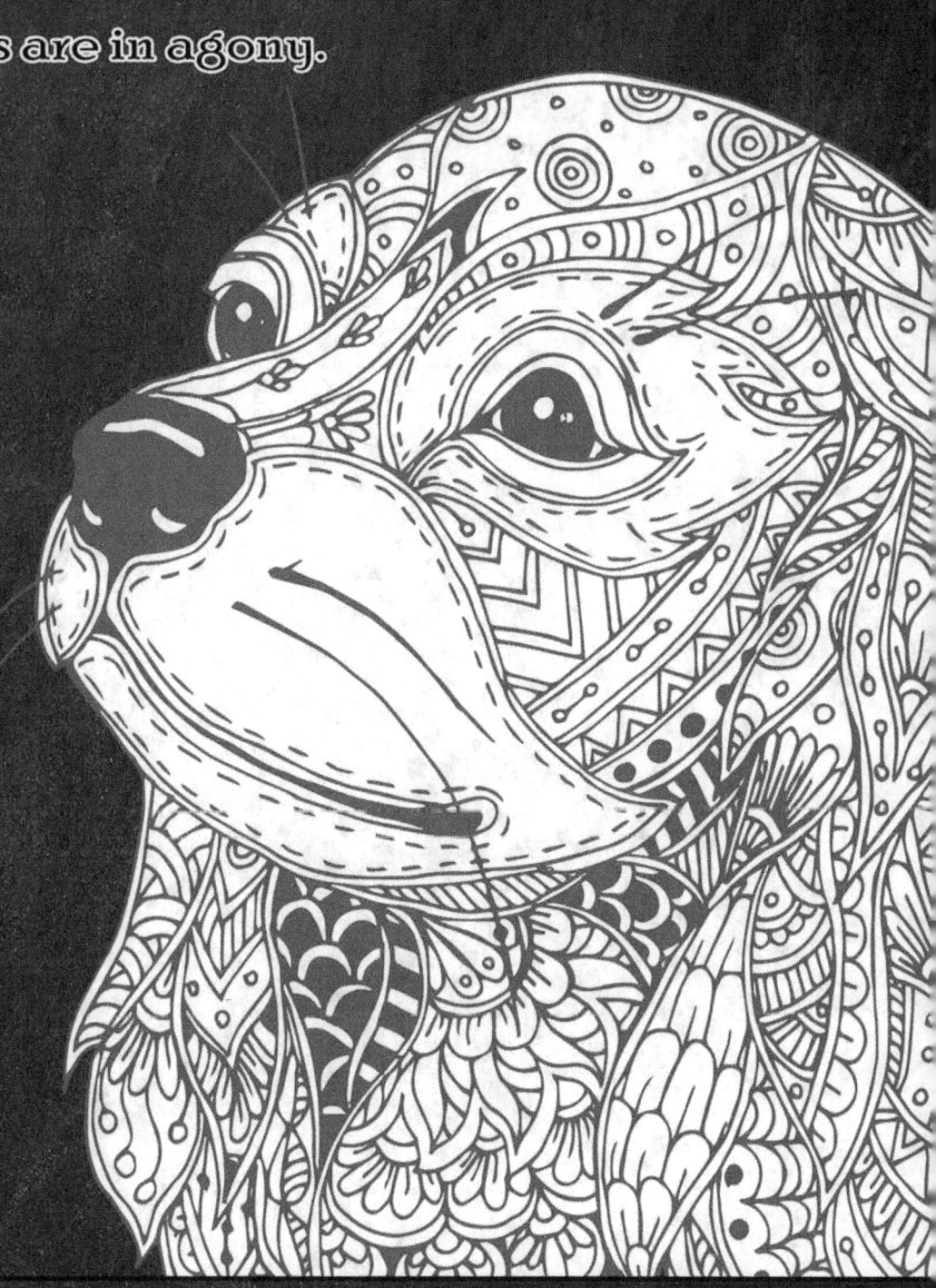

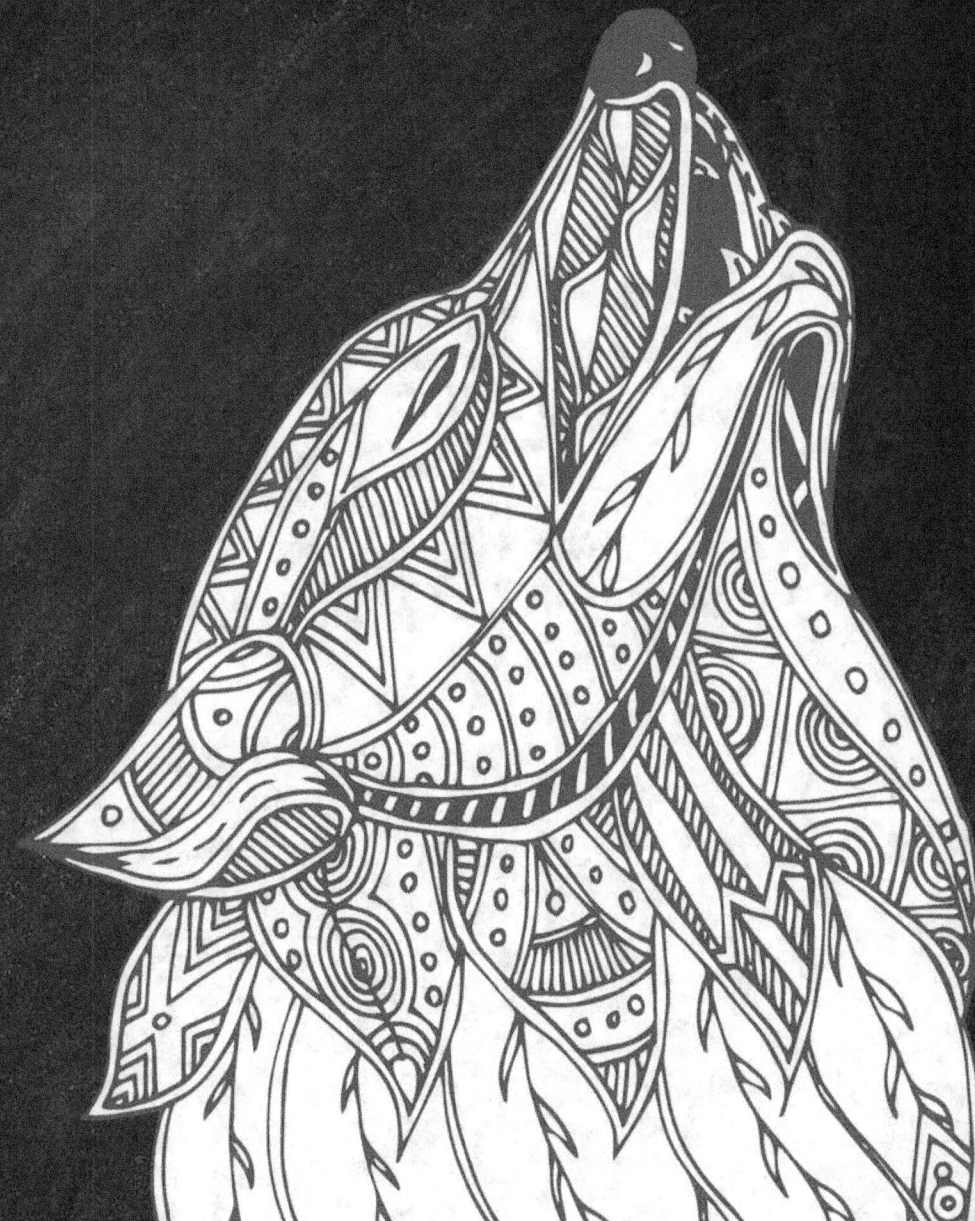

He sent out his word and healed them,

and delivered
them from their destruction.

Psalm 107:20

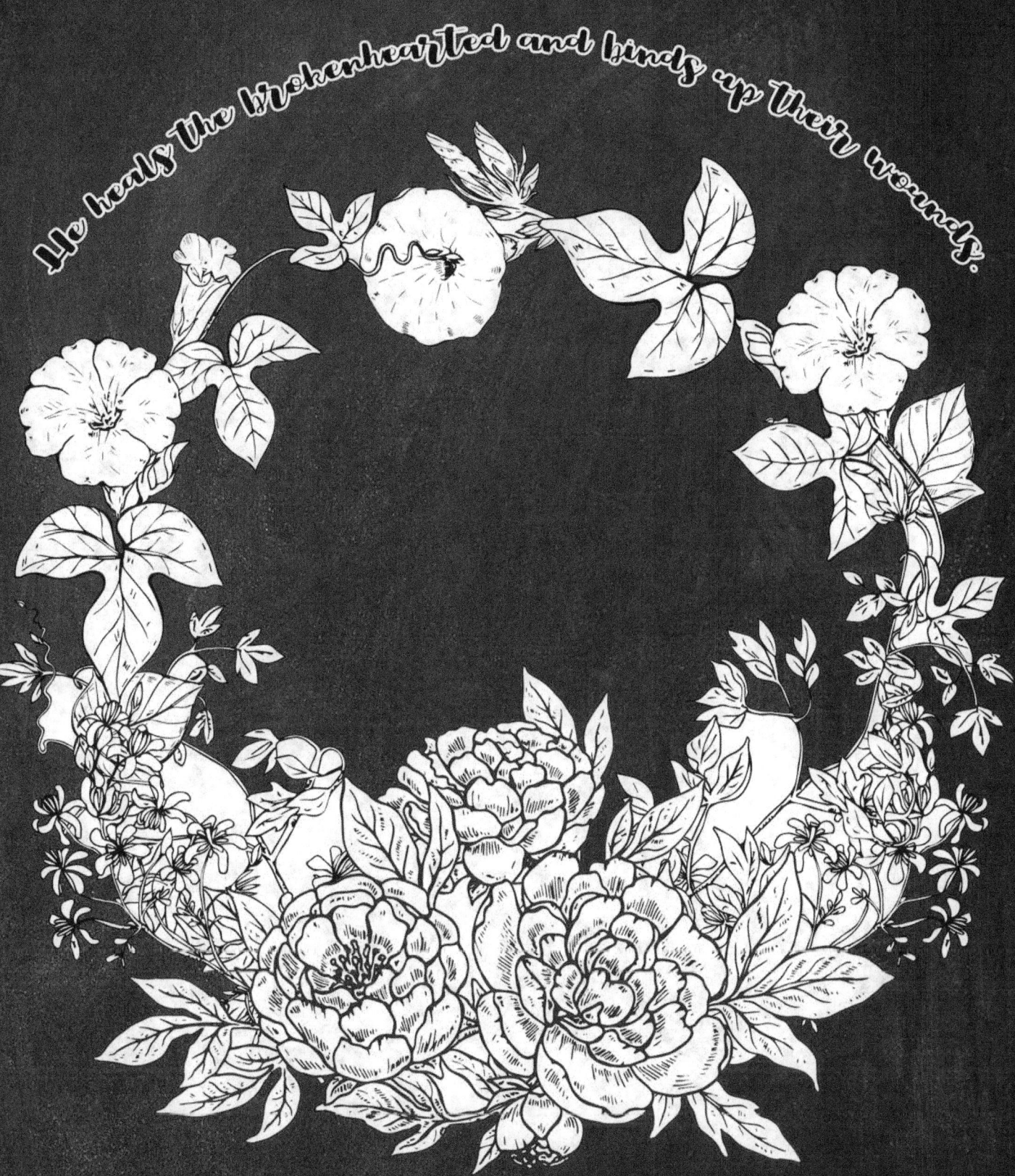

A joyful heart is good medicine, but a crushed spirit dries up the bones.

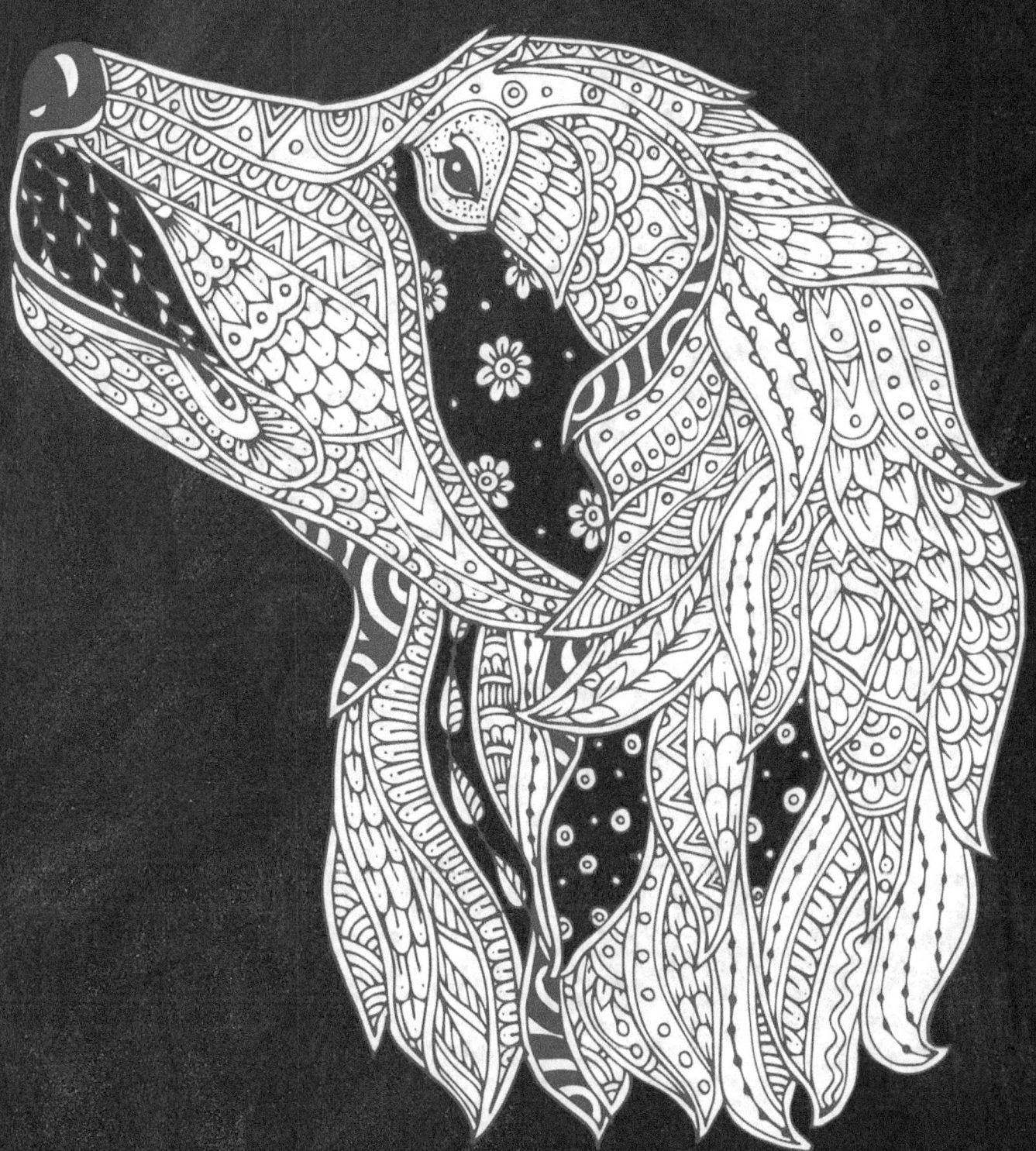

Proverbs 17:22

And the Lord will strike Egypt, striking and healing,

and they will return to the Lord,

and he will listen to their

pleas for mercy and heal them.

Isaiah 19:22

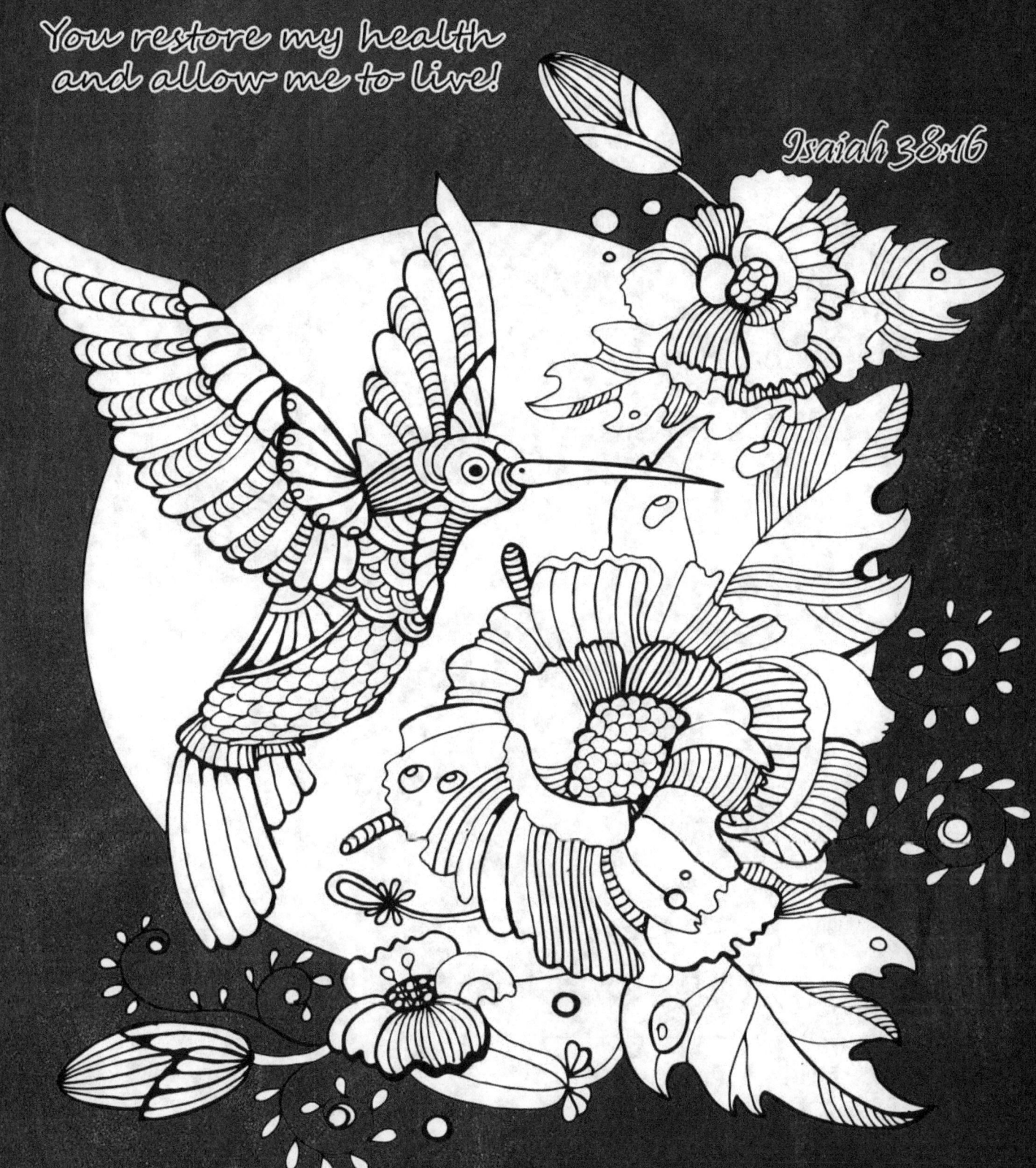

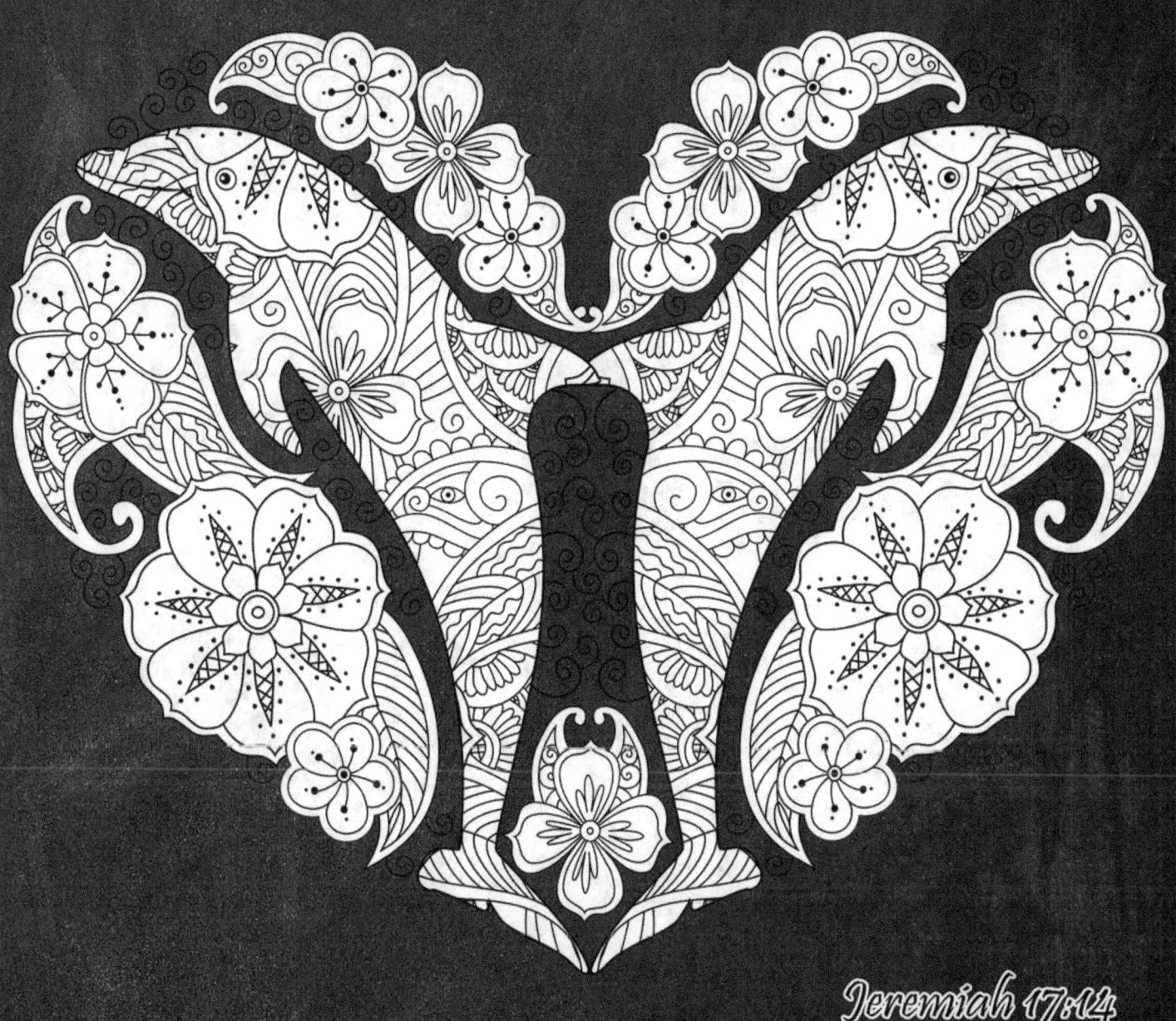

For I will restore health to you,

and your wounds I will heal,

DECLARES THE LORD.

Jeremiah 30:17

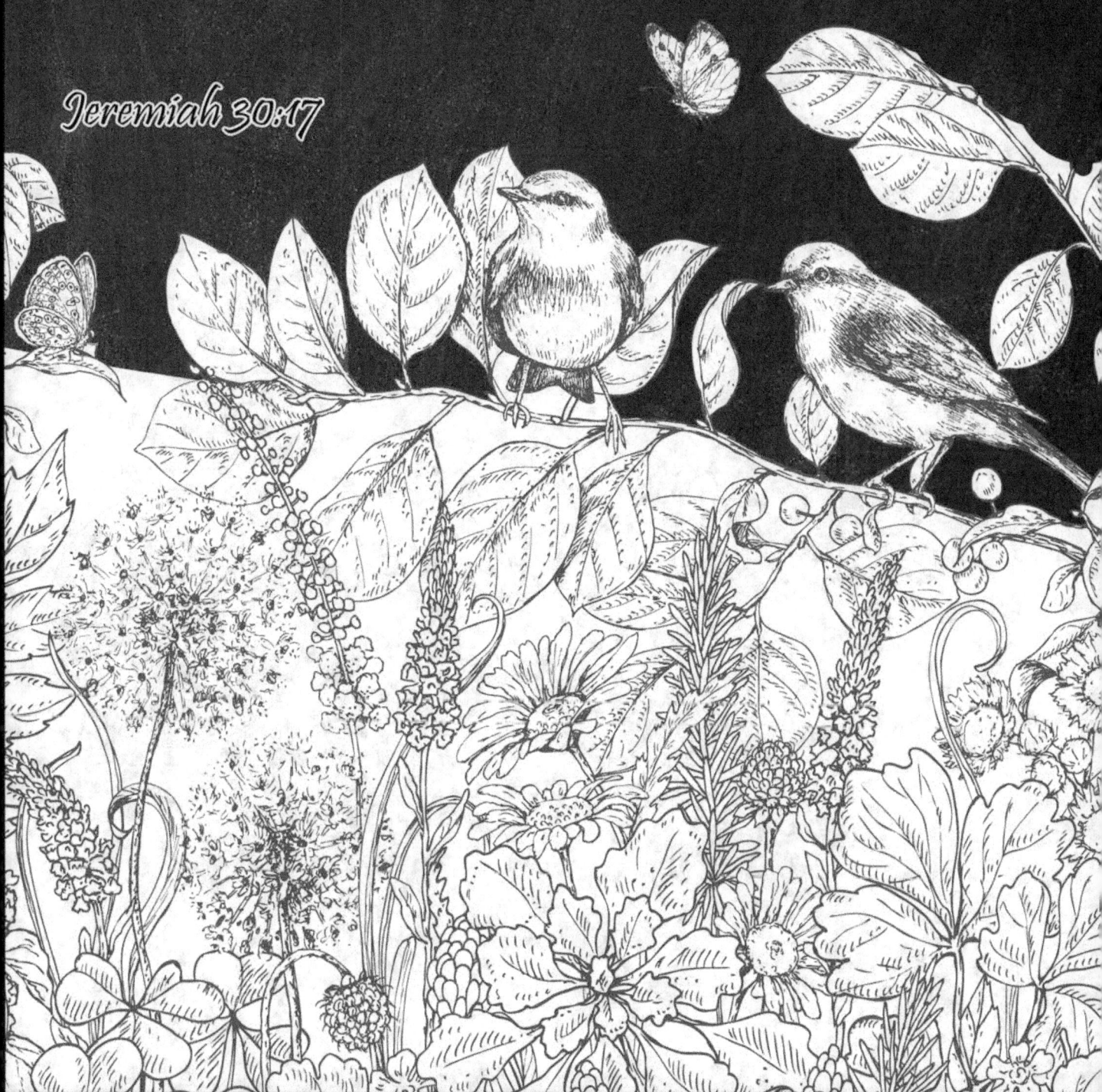

And the power of the lord was with him to heal

Luke 5:17

Heal the sick in it and say to them,

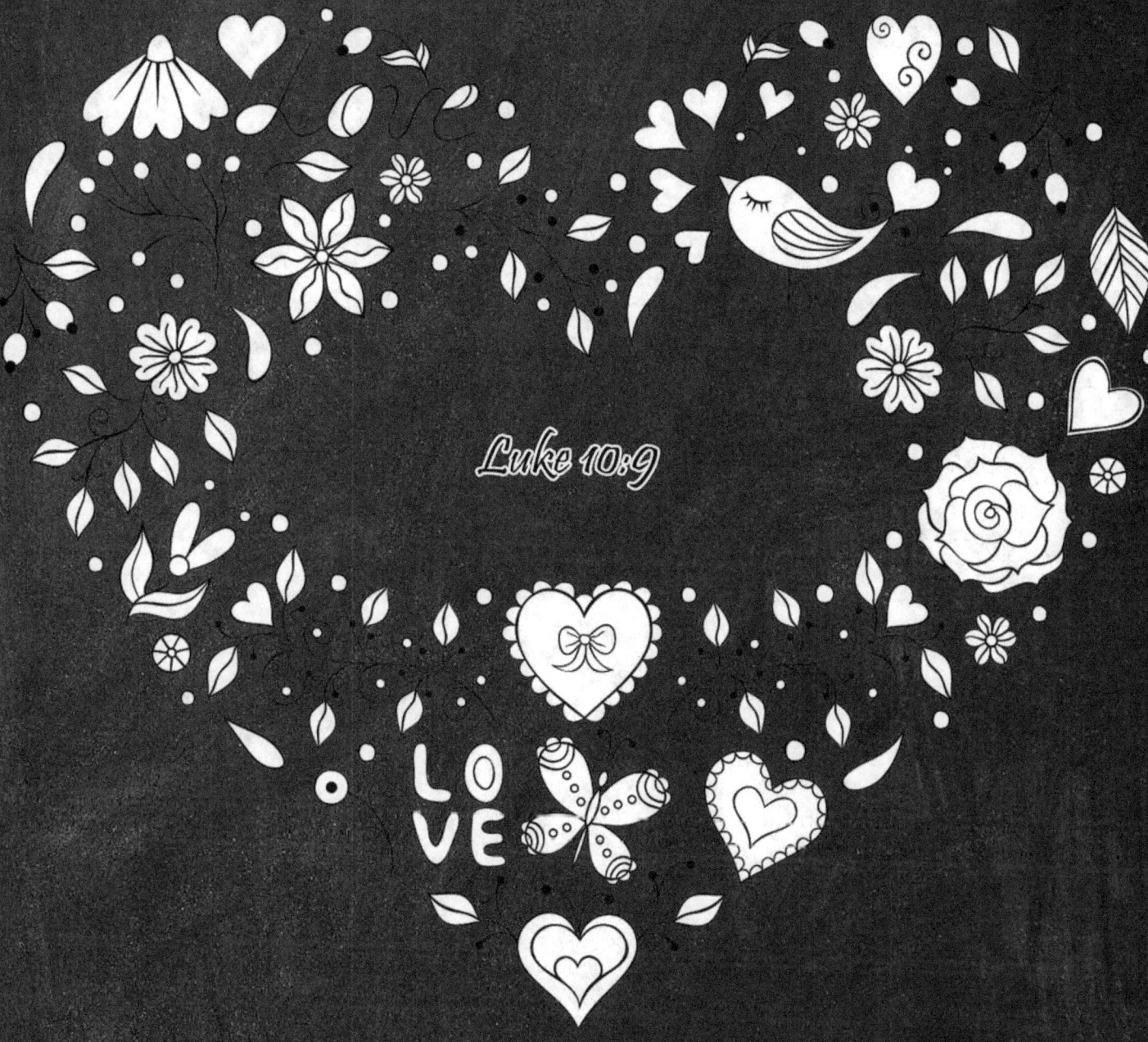

Luke 10:9

The kingdom of God has come near to you.

But they remained silent.

Then He took him and healed him and sent him away.

Luke 14:4

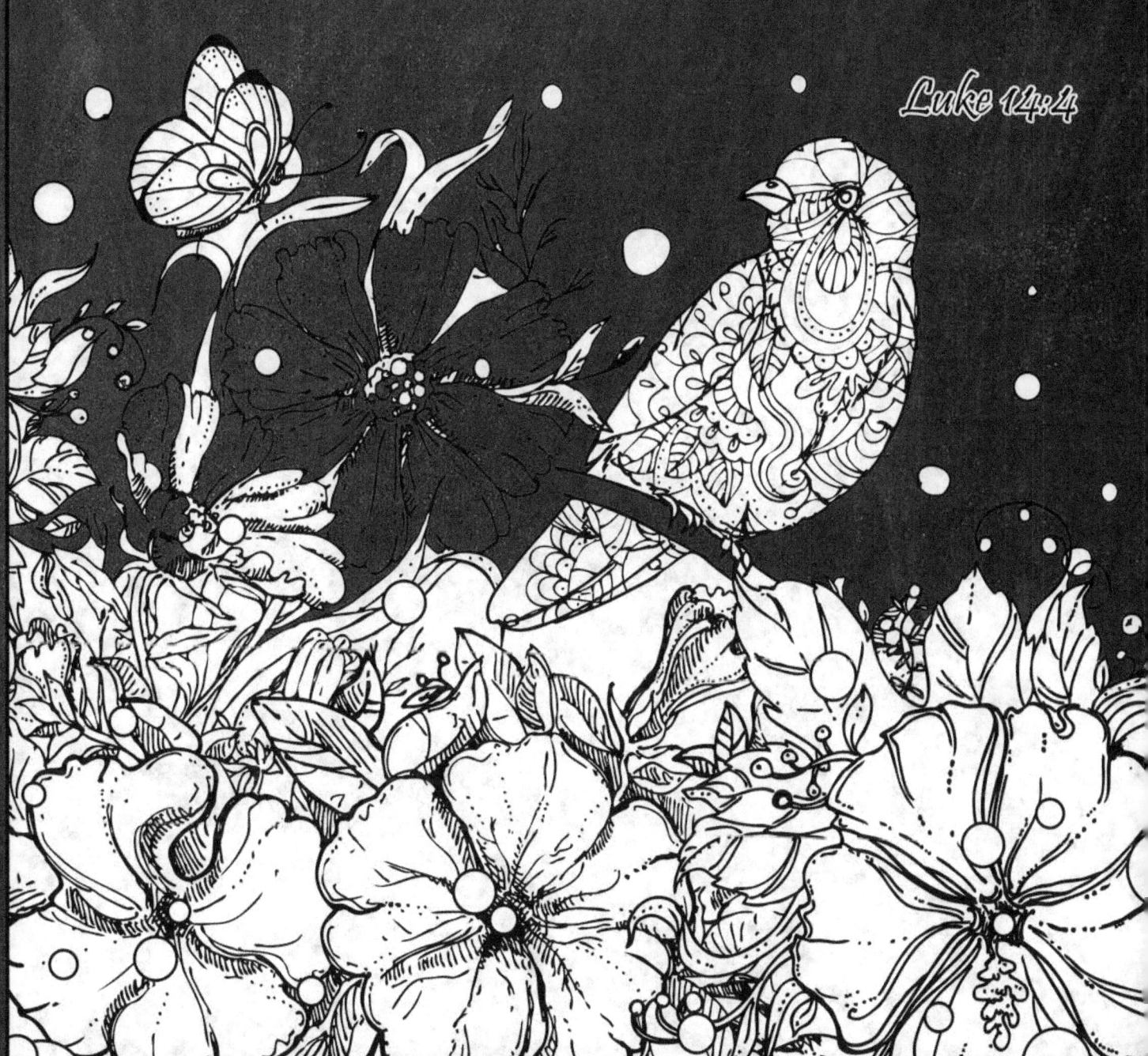

While you stretch out your hand to heal, and signs and wonders are performed

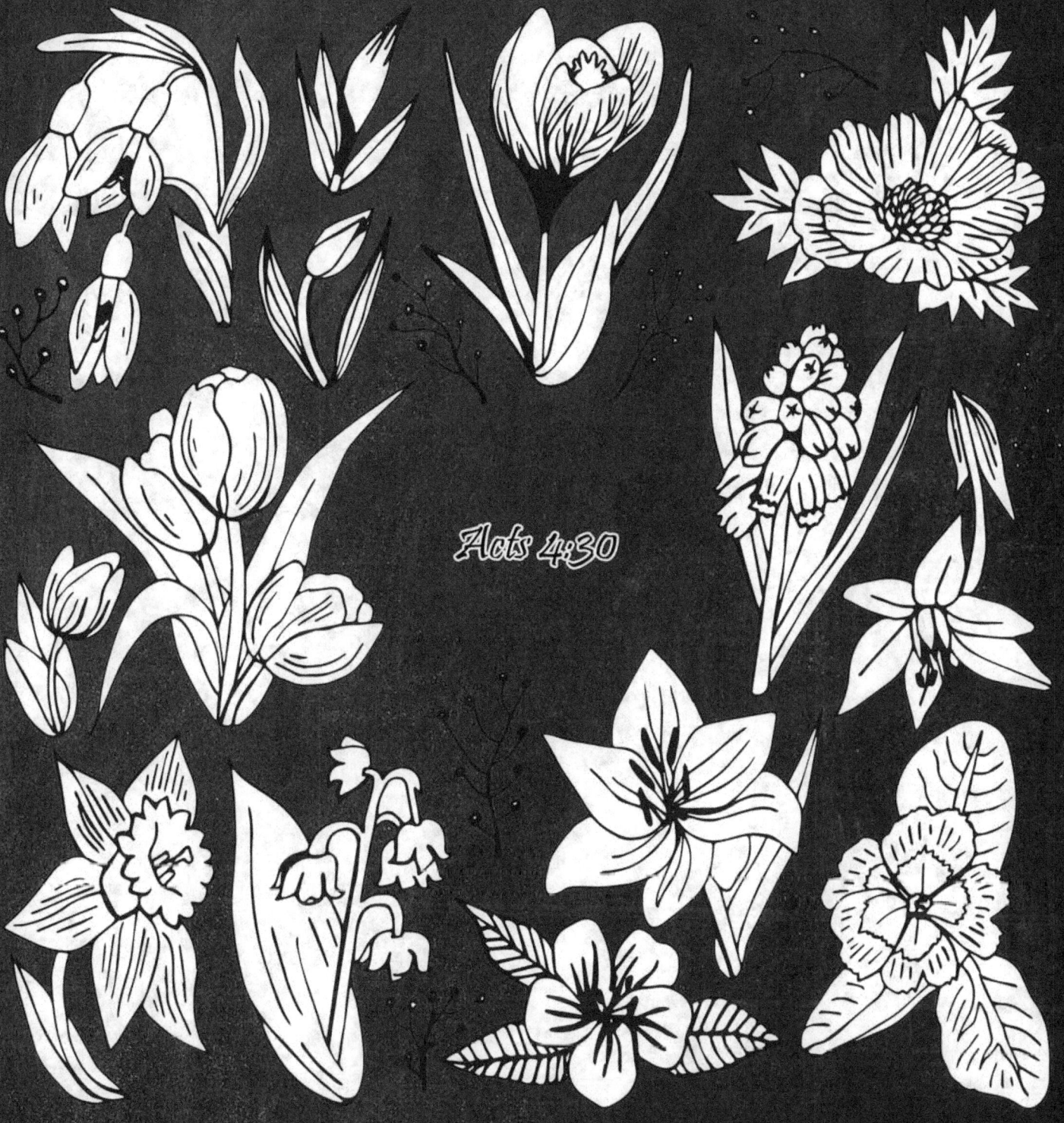

Acts 4:30

THROUGH THE NAME OF YOUR HOLY SERVANT JESUS.

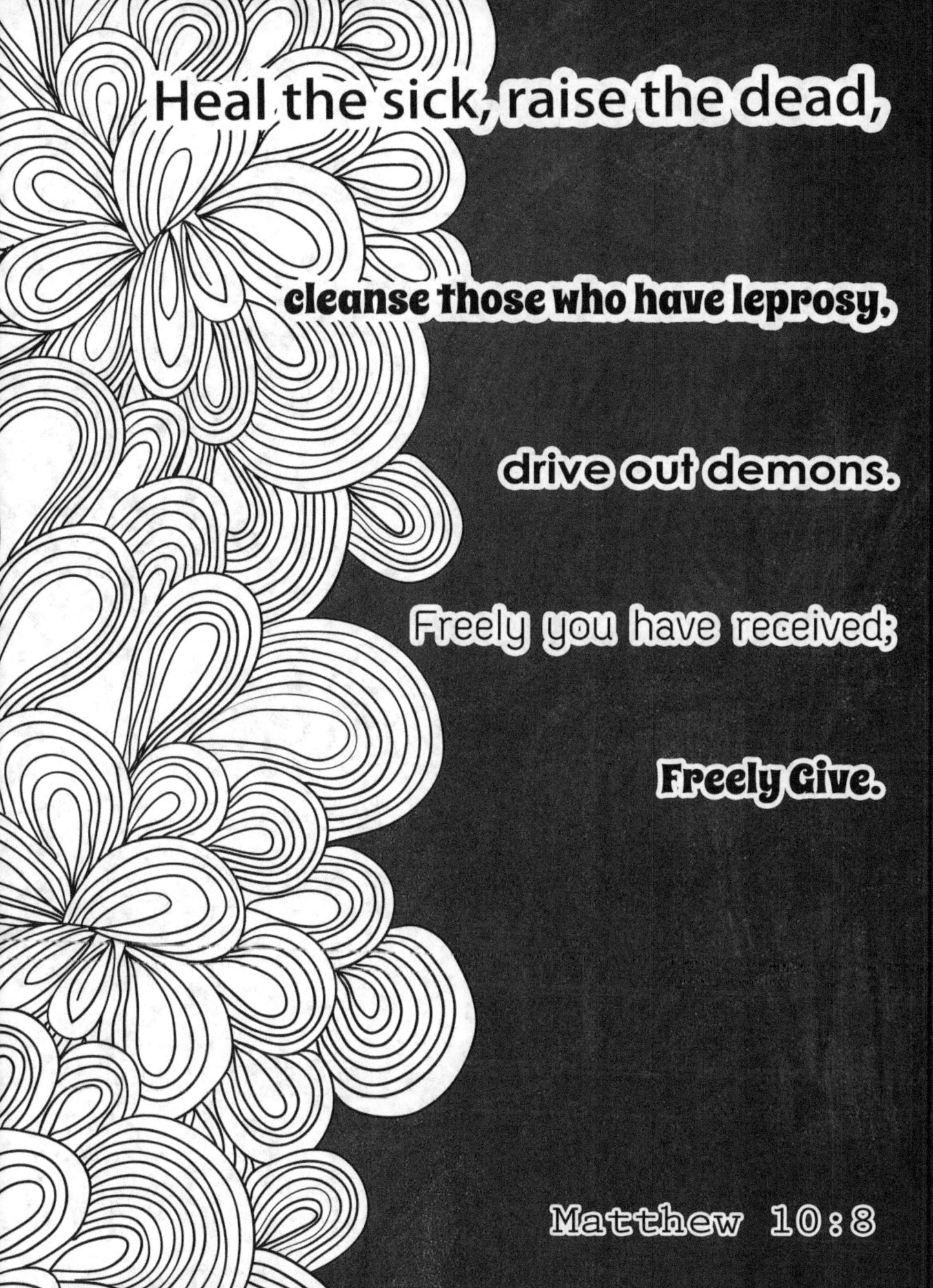

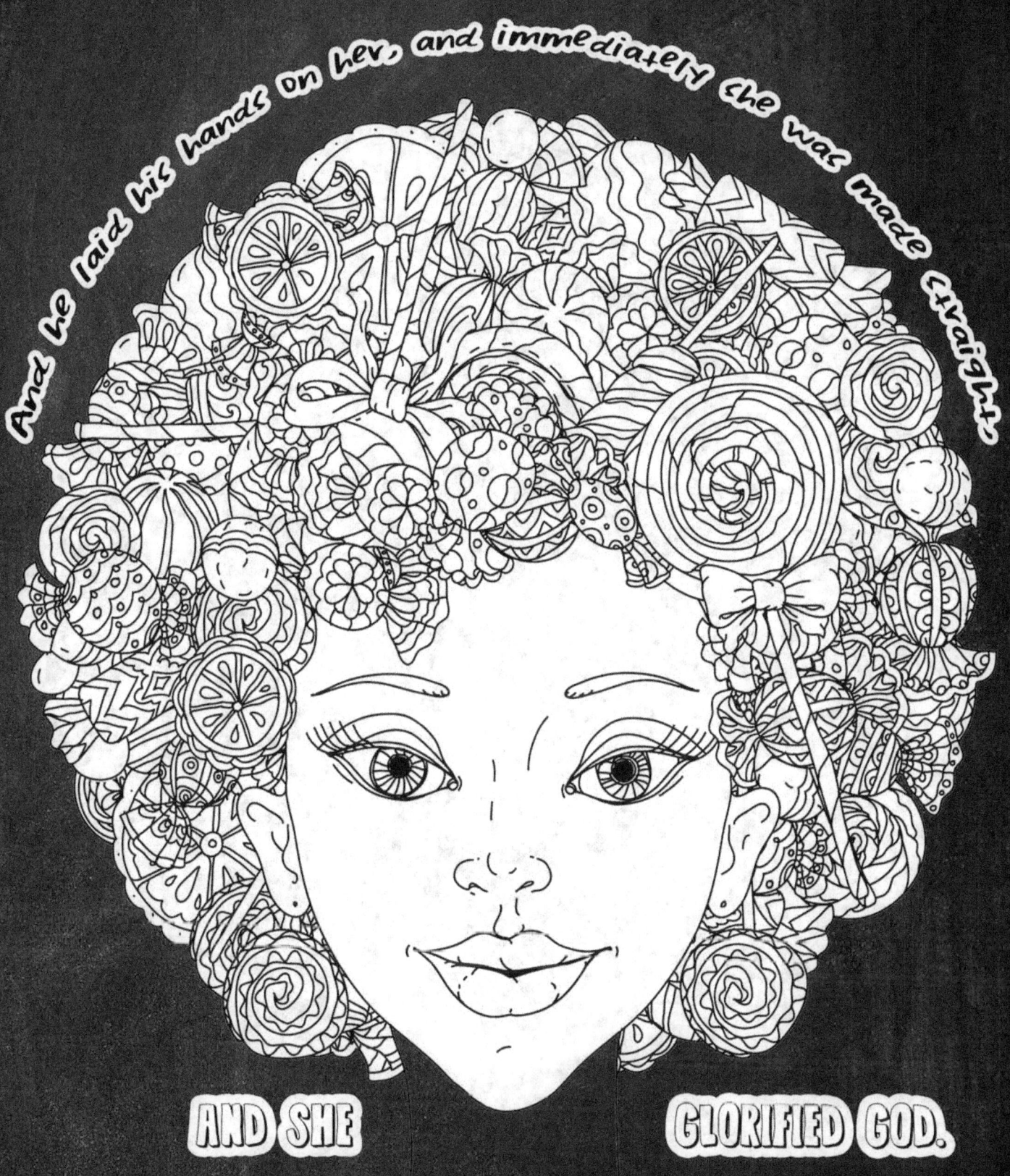

"HE HAS BLINDED THEIR EYES AND HARDENED THEIR HEART, LEST THEY SEE WITH THEIR EYES, AND UNDERSTAND WITH THEIR HEART, AND TURN, AND I WOULD HEAL THEM."

John 12:40

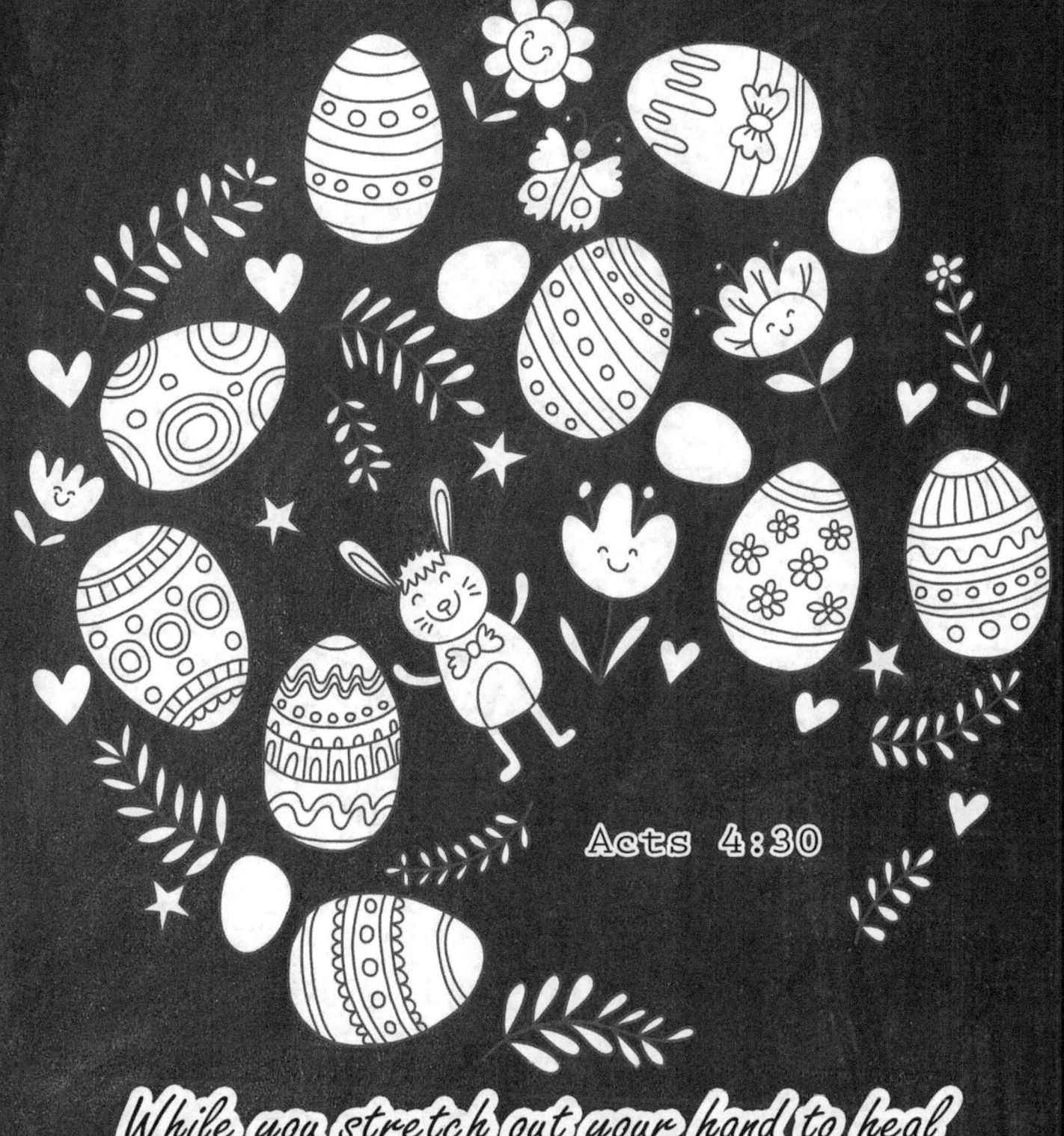

Acts 4:30

While you stretch out your hand to heal and signs and wonders are performed through the name of **YOUR HOLY SERVANT JESUS.**

And Peter said to him,

"Aeneas, Jesus Christ heals you; rise and make your bed."

And immediately he rose.

Acts 9:34

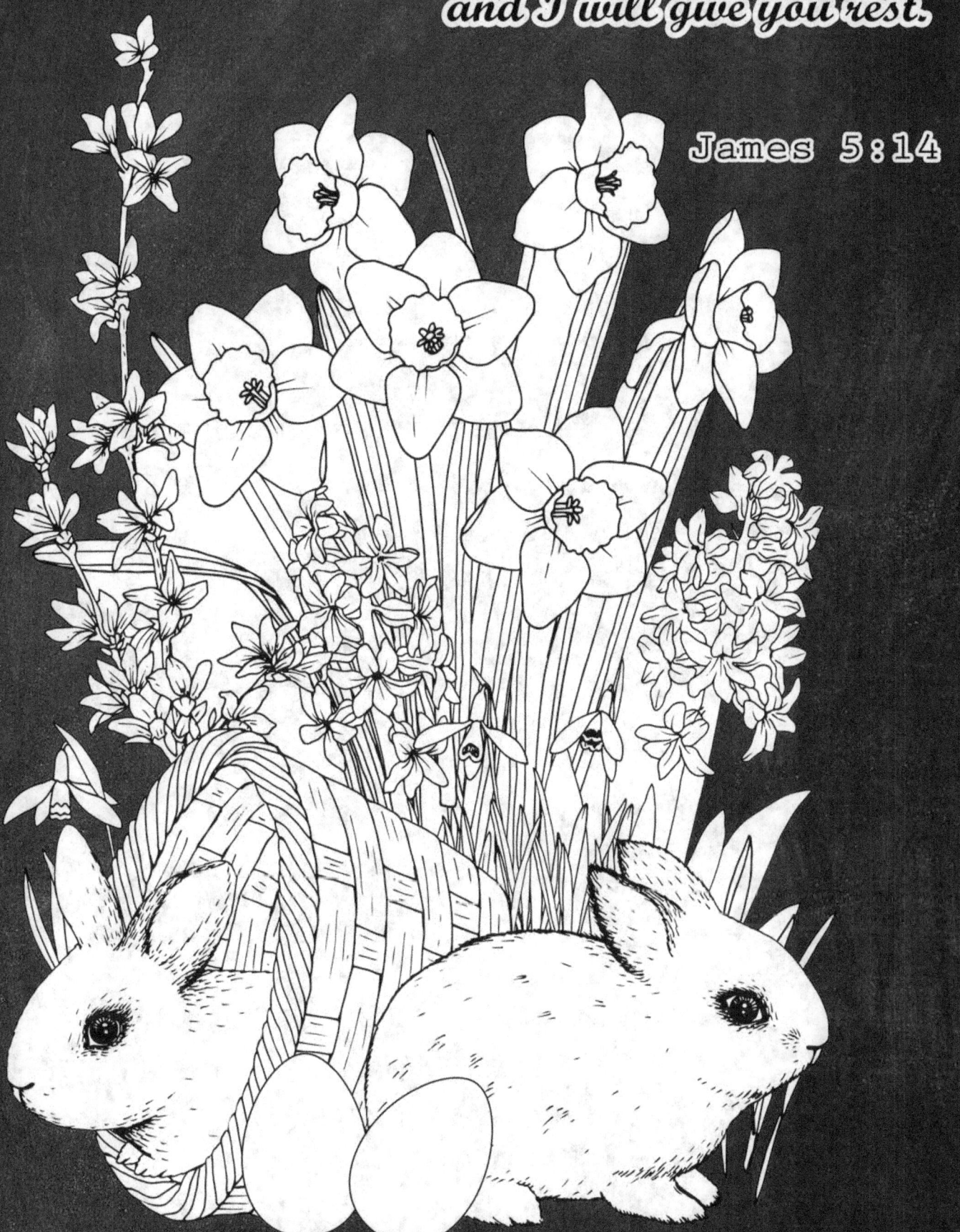

When Jesus had entered Capernaum, a centurion came to him, asking for help.

Matthew 8:5

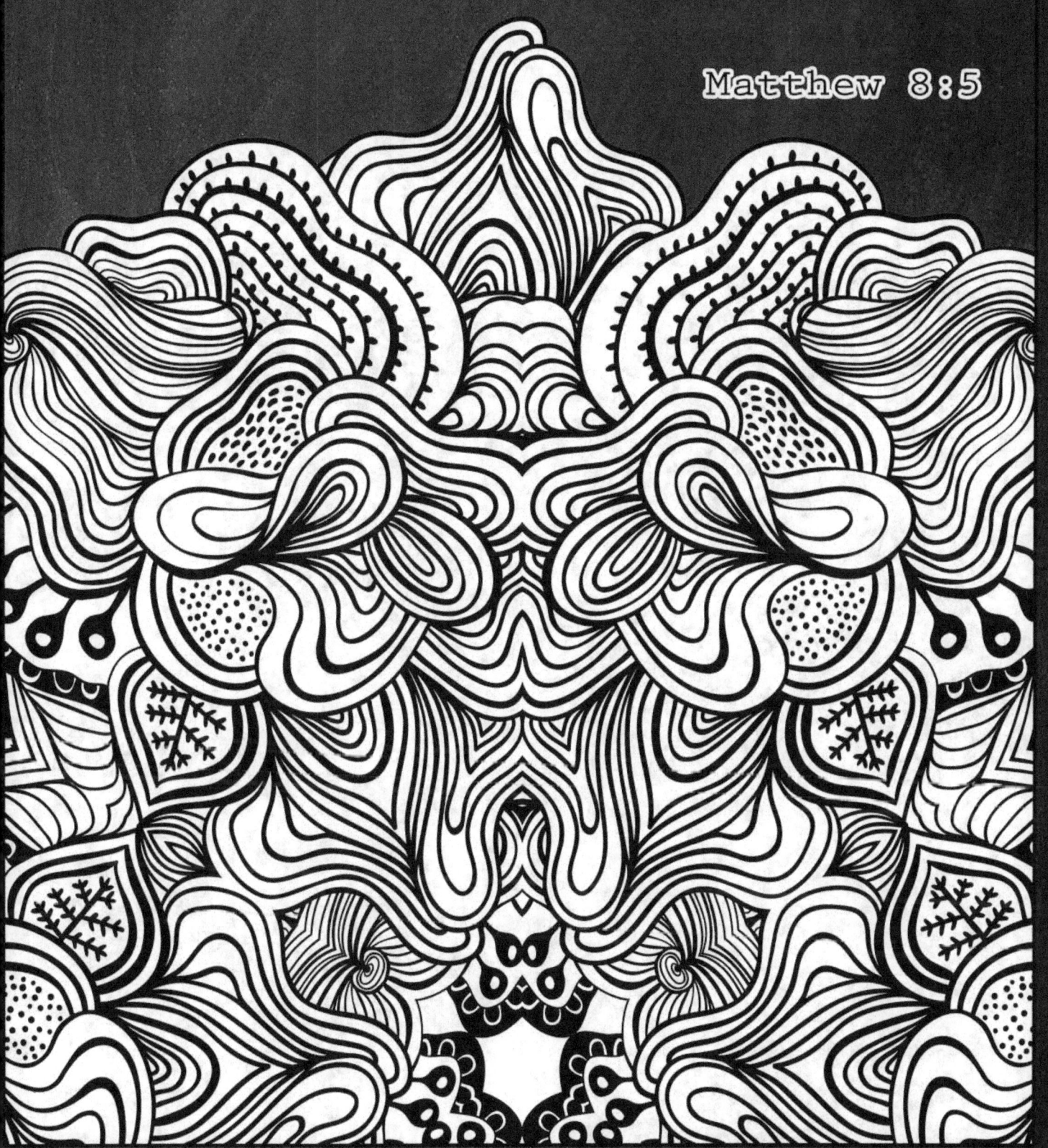

Join Us >> bit.ly/get_sample_free

- Get Free "Reviw Copies" of our New releases
- Exclusive offers and book giveaways
- More events from our community

Thank you

www.ingramcontent.com/pod-product-compliance
Lightning Source LLC
Chambersburg PA
CBHW081128180526
45170CB00008B/3044